Jonathan's Book of Abstract Designs

By Jonathan Jay Brandstater

Copyright 2017
All rights reserved.

For Lisa

Introduction

Drawing and coloring are relaxing activities. The designs in this book were originally coloring pages and I used Artrage ™, a graphics program, to fill in the outlines and complete the illustrations. There are several graphics programs available. Some may be purchased; others are free. Many PCs feature Microsoft Paint ™ for example, along with other default Windows ™ applications.

You can create your own coloring pages and books. Using a computer graphics program is an option but you can also do well with black markers and paper. Once you have drawn patterns you like, you can fill them in with crayons, colored pencils, and /or colored markers. Designs need not be complicated. A useful rule of

thumb is, Keep it simple. Also, have fun and really enjoy the process.

The rest of this book consists of a variety of illustrations, each created with a different style. A few are whimsical; they are drawn in the manner of Kawaii (Japanese for "cute") cartoons. Others consist of groups of similar shapes, such as squares, triangles and circles. About two years ago, I taught myself to draw Zentangles ™. Many illustrations in this book are based on this method. Speaking personally, I approach each drawing as if it was a meditation. As far as I am concerned, it is one.

Perhaps <u>Jonathan's Book of Abstract Designs</u> will inspire you to create your own works of art. The possibilities are endless.

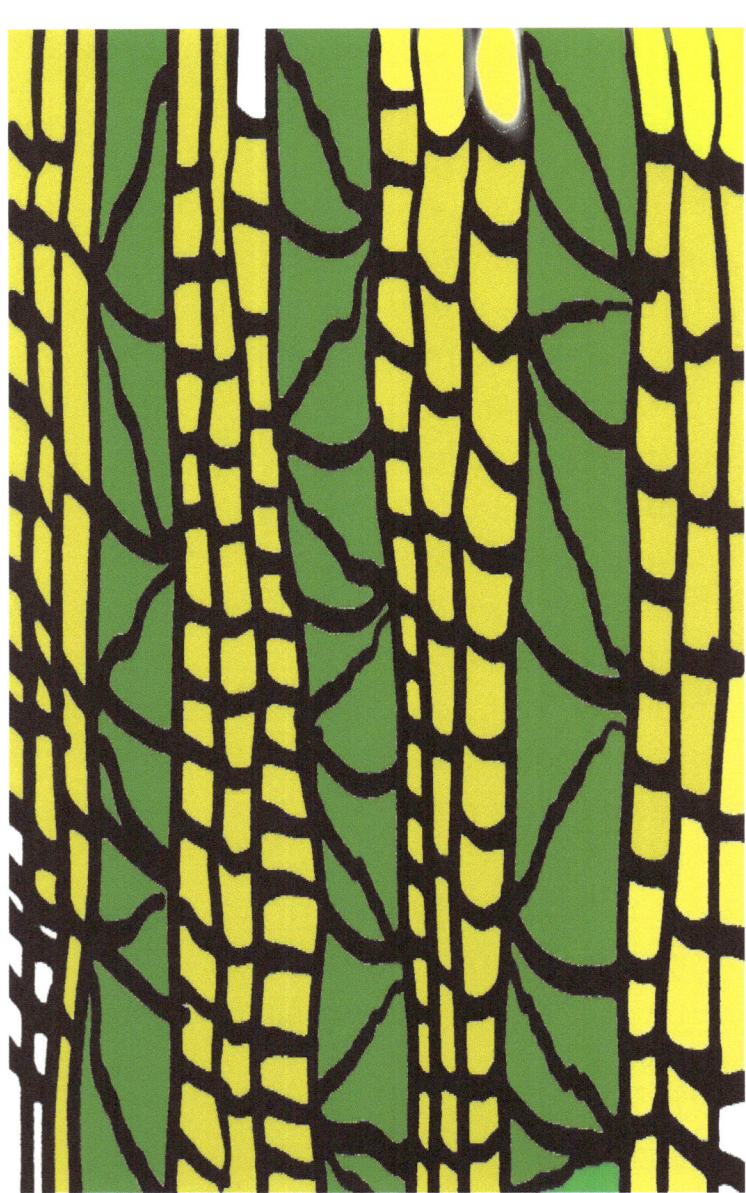

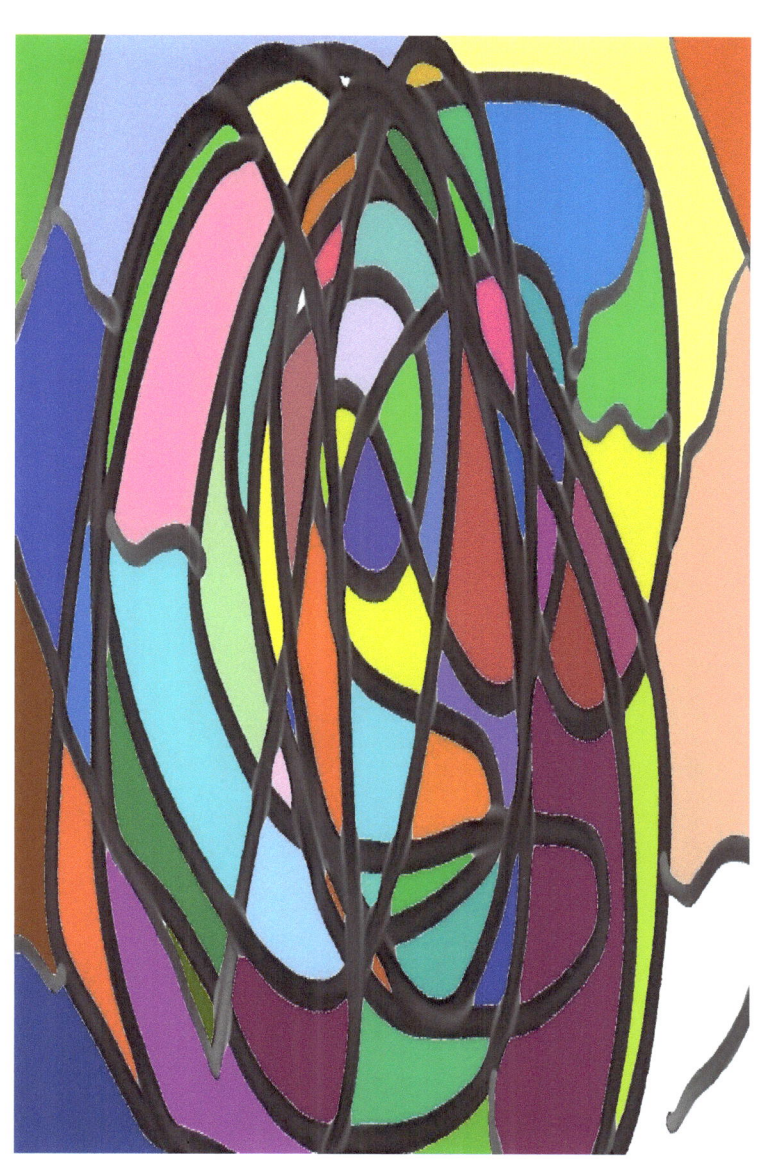

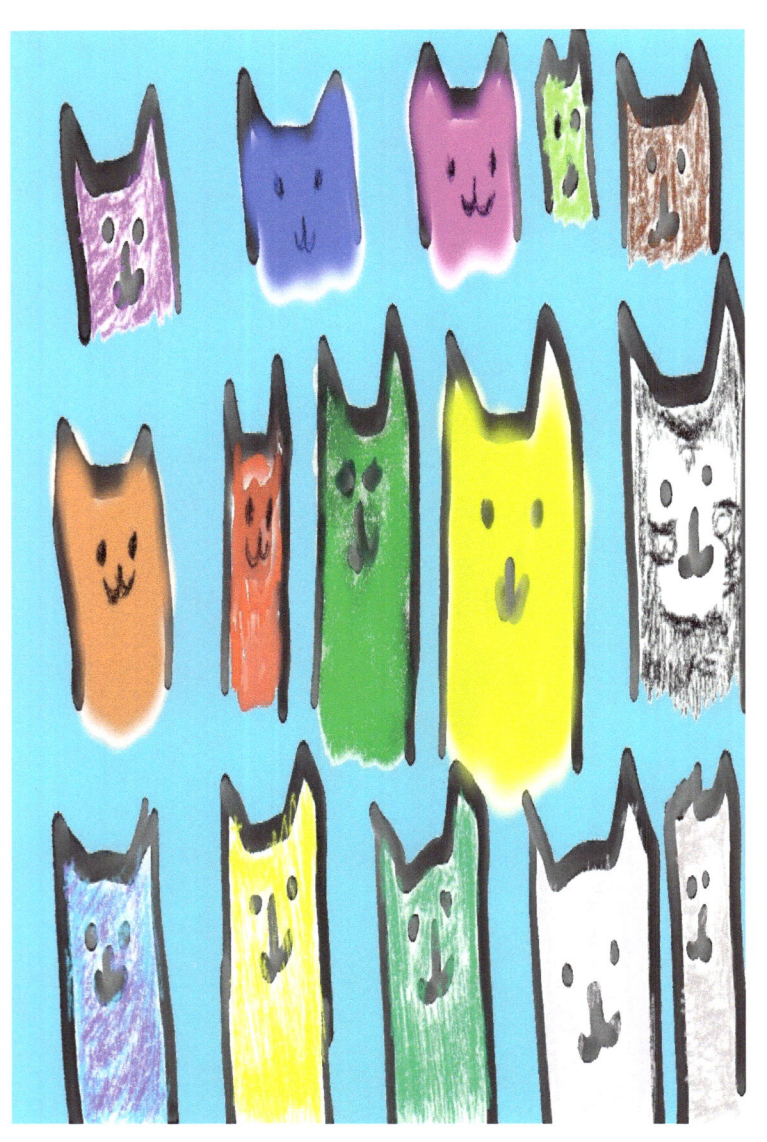

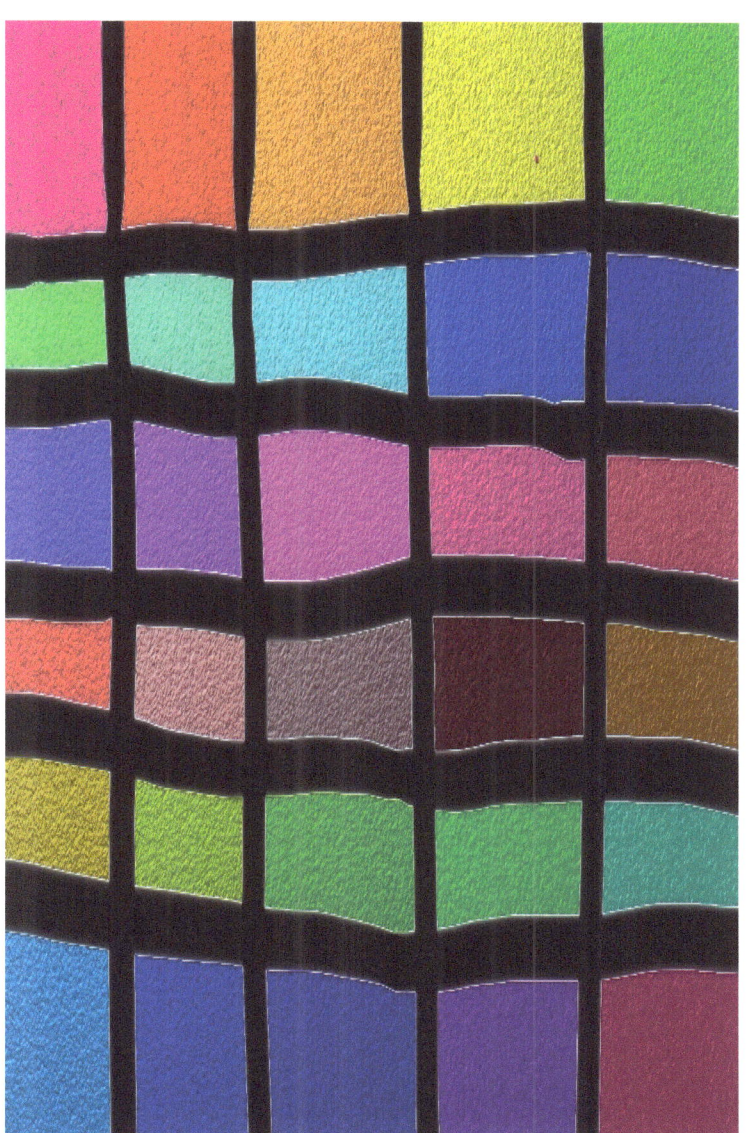

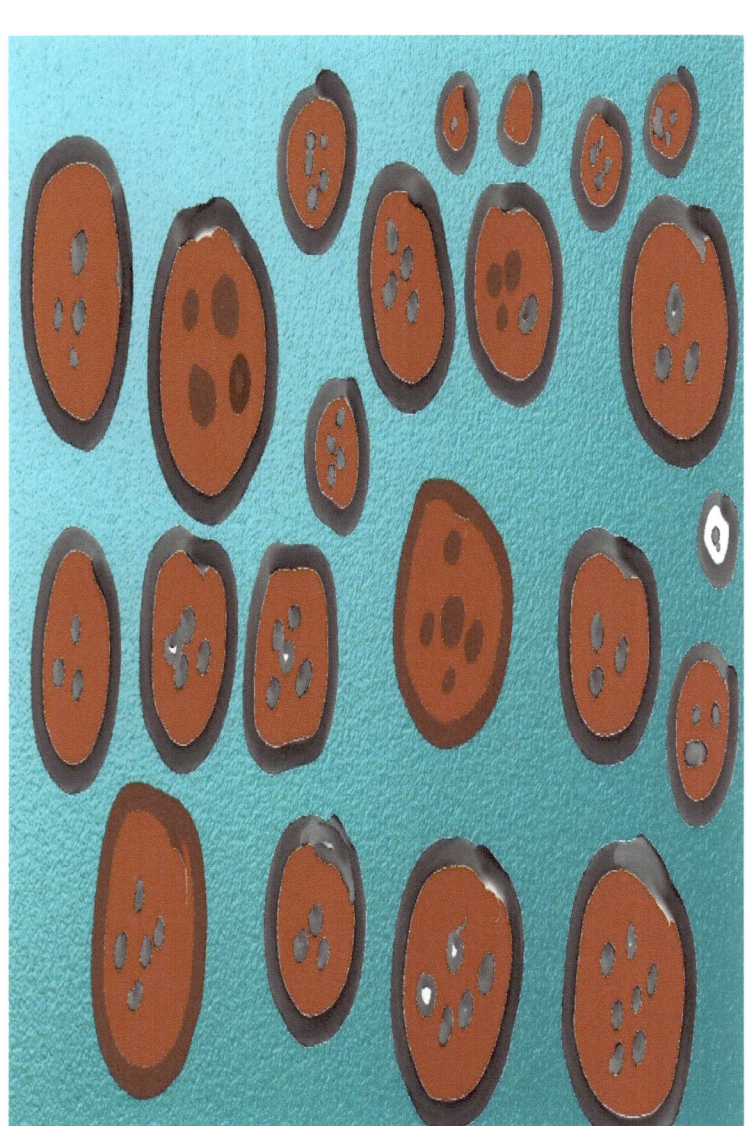

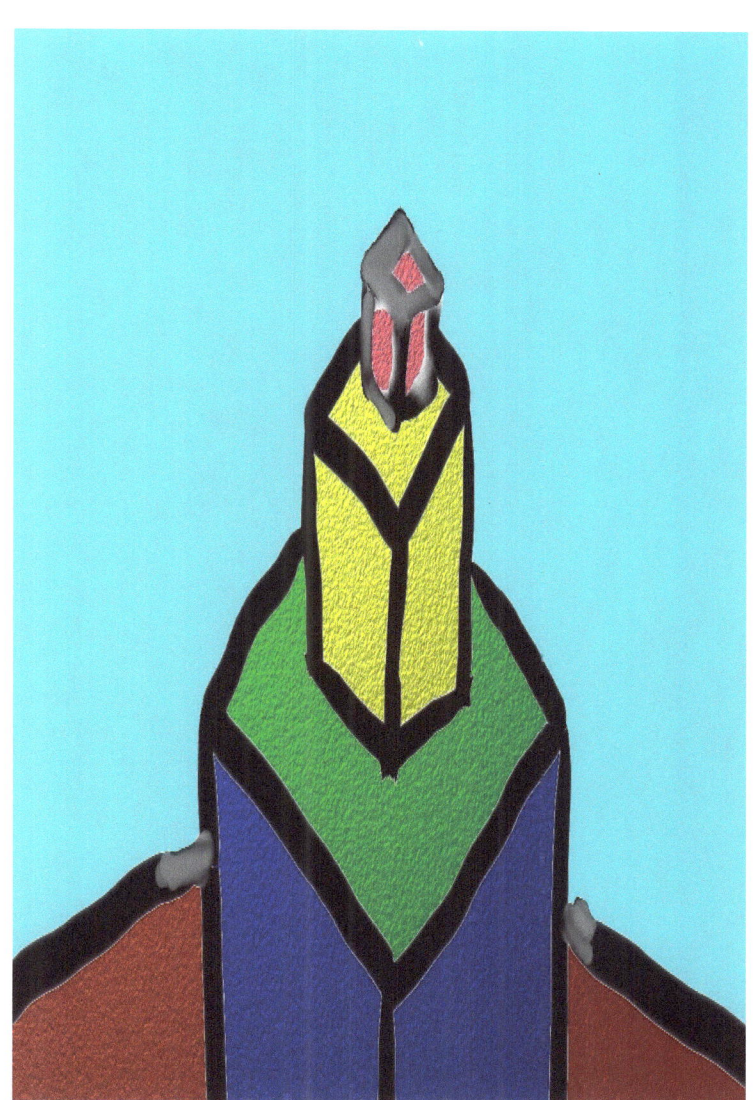

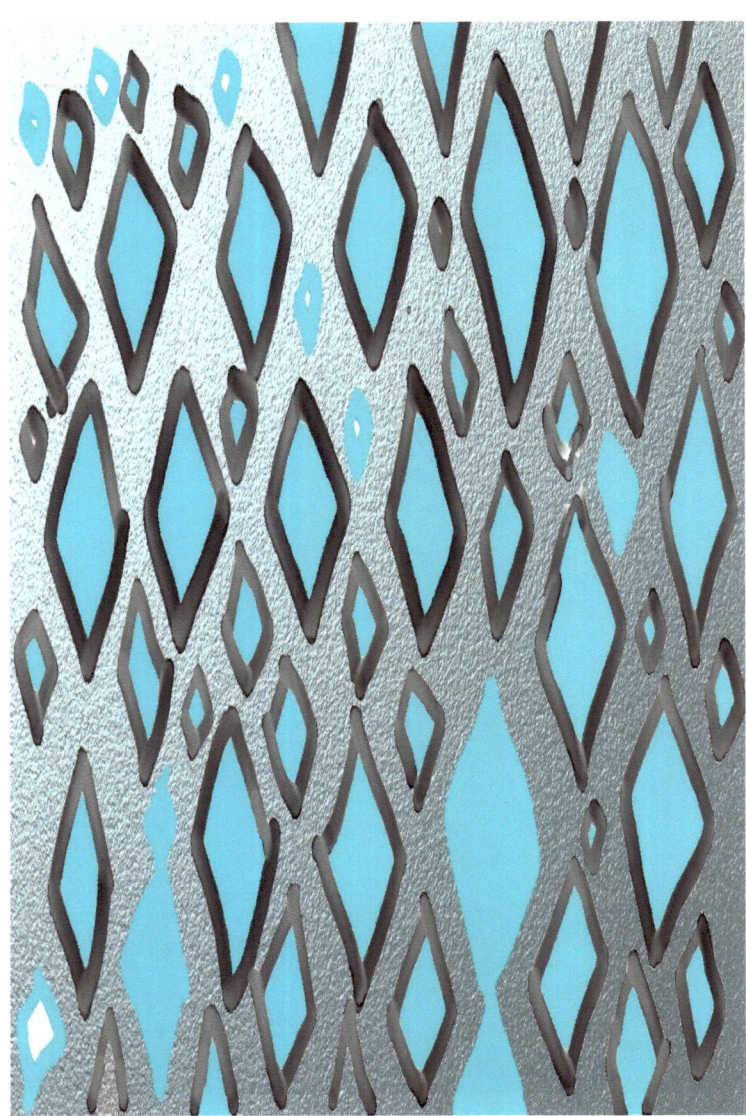

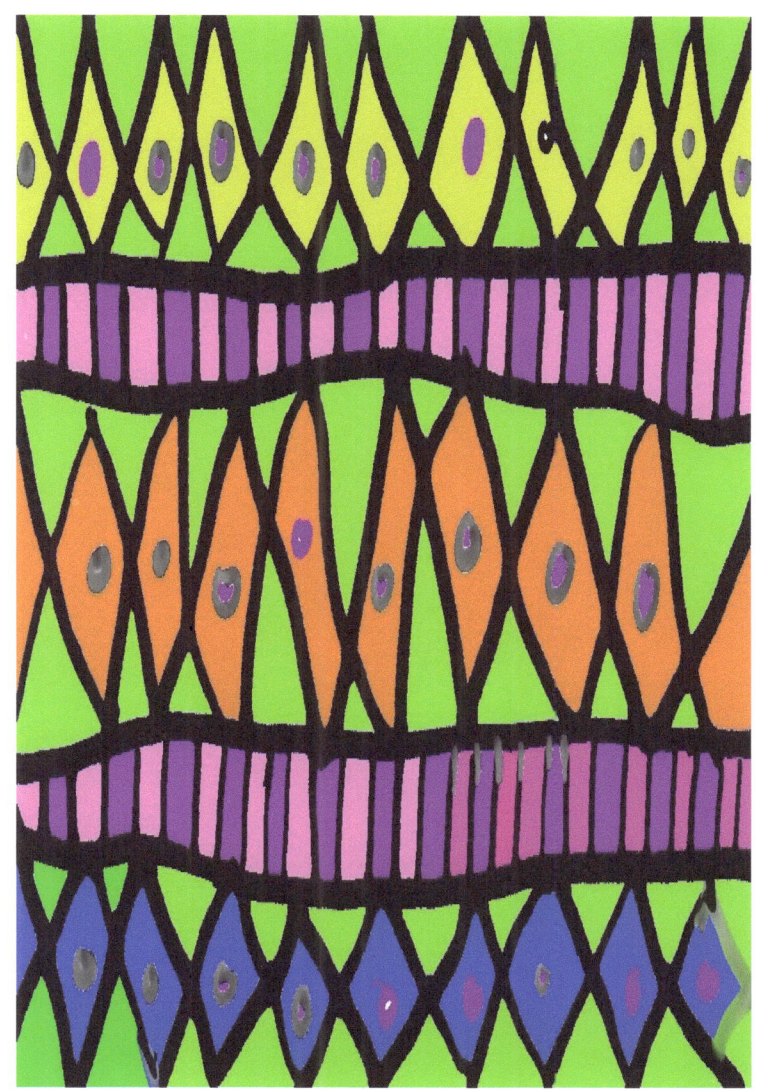

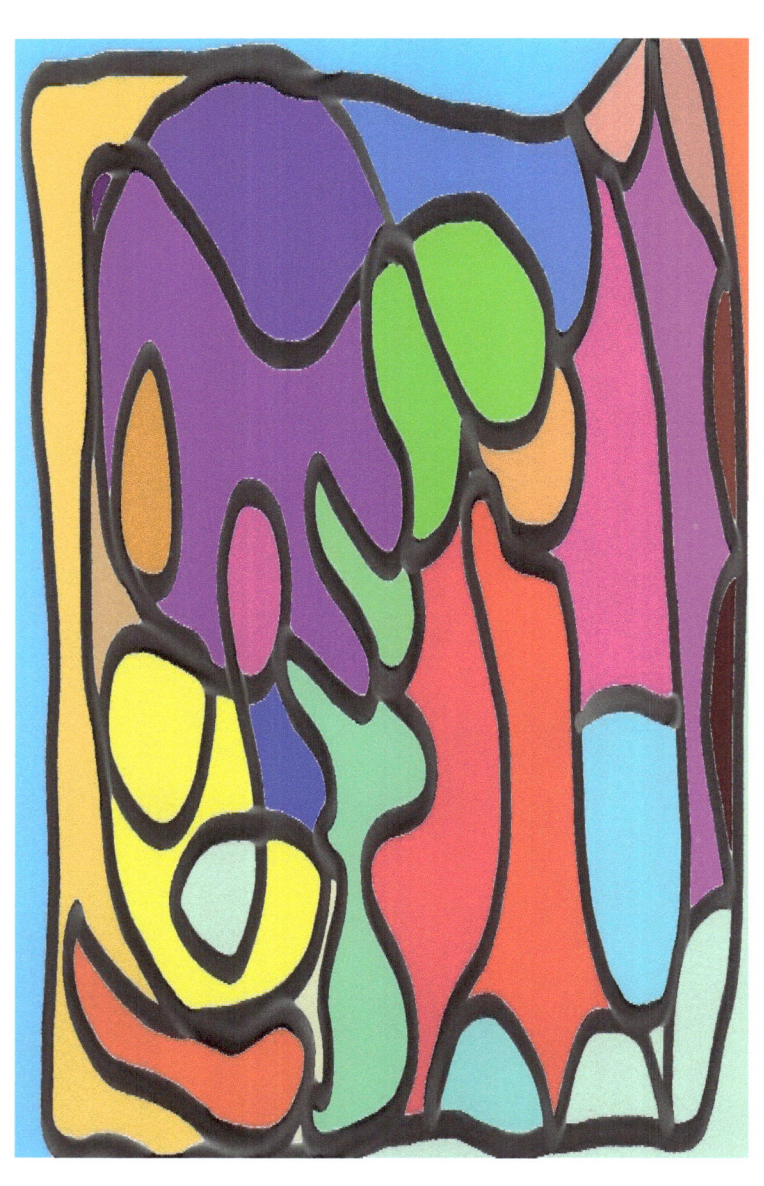

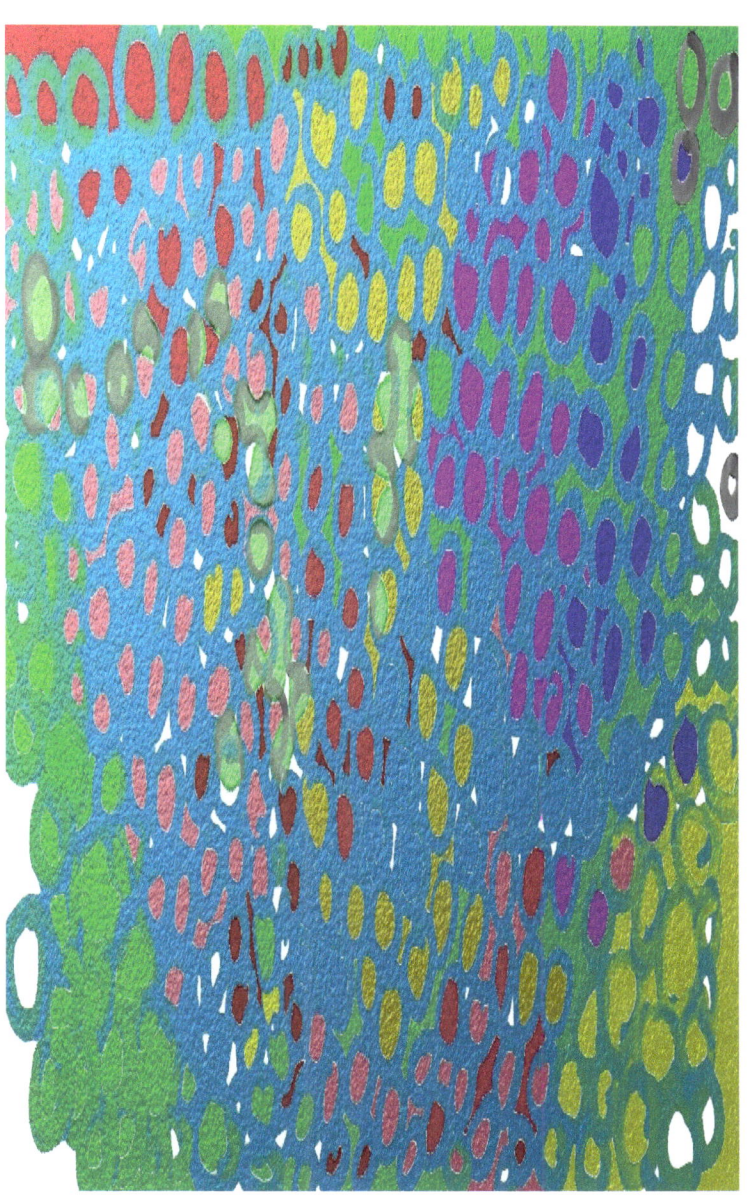

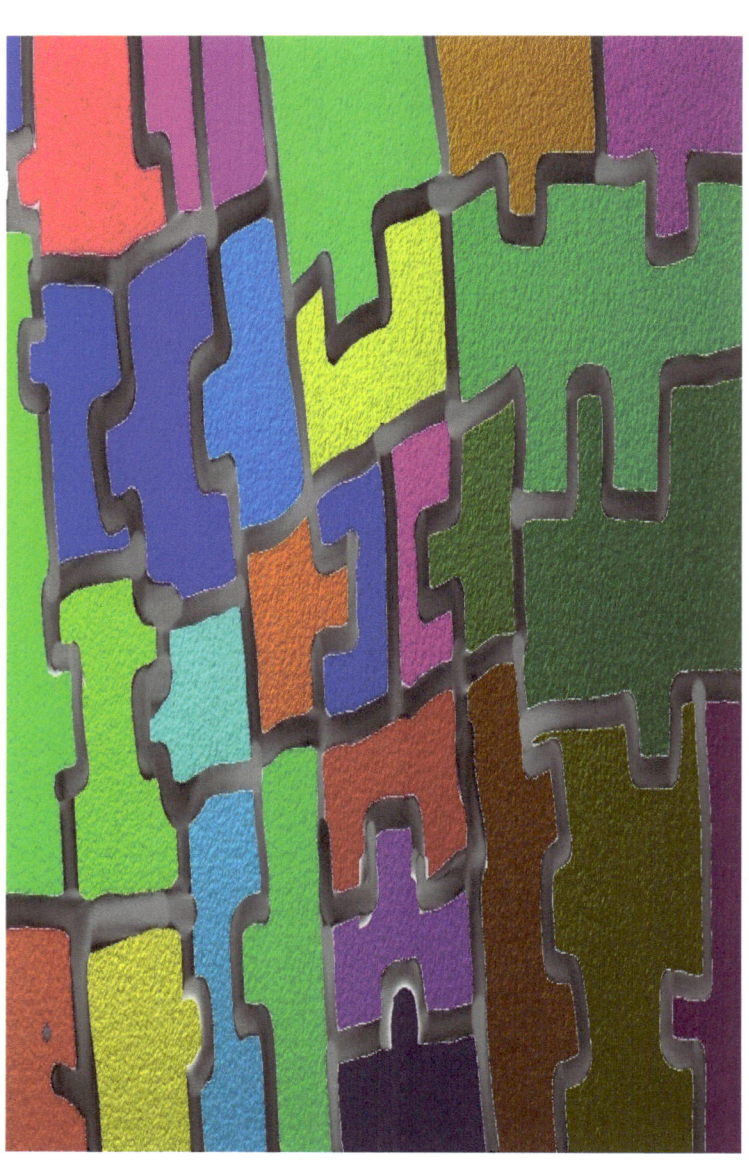

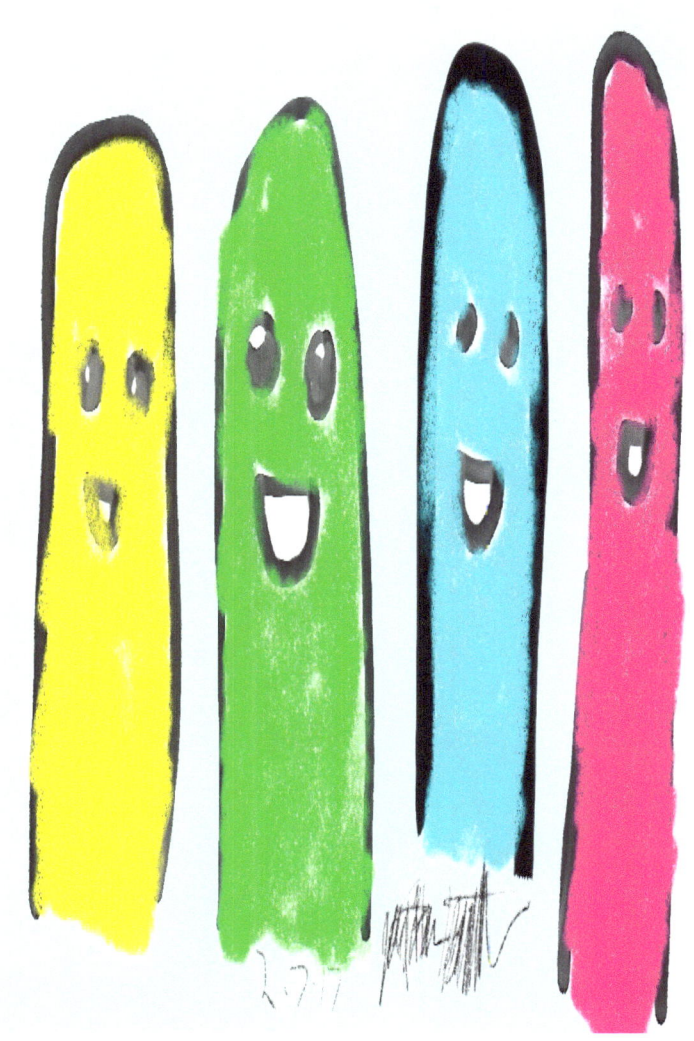

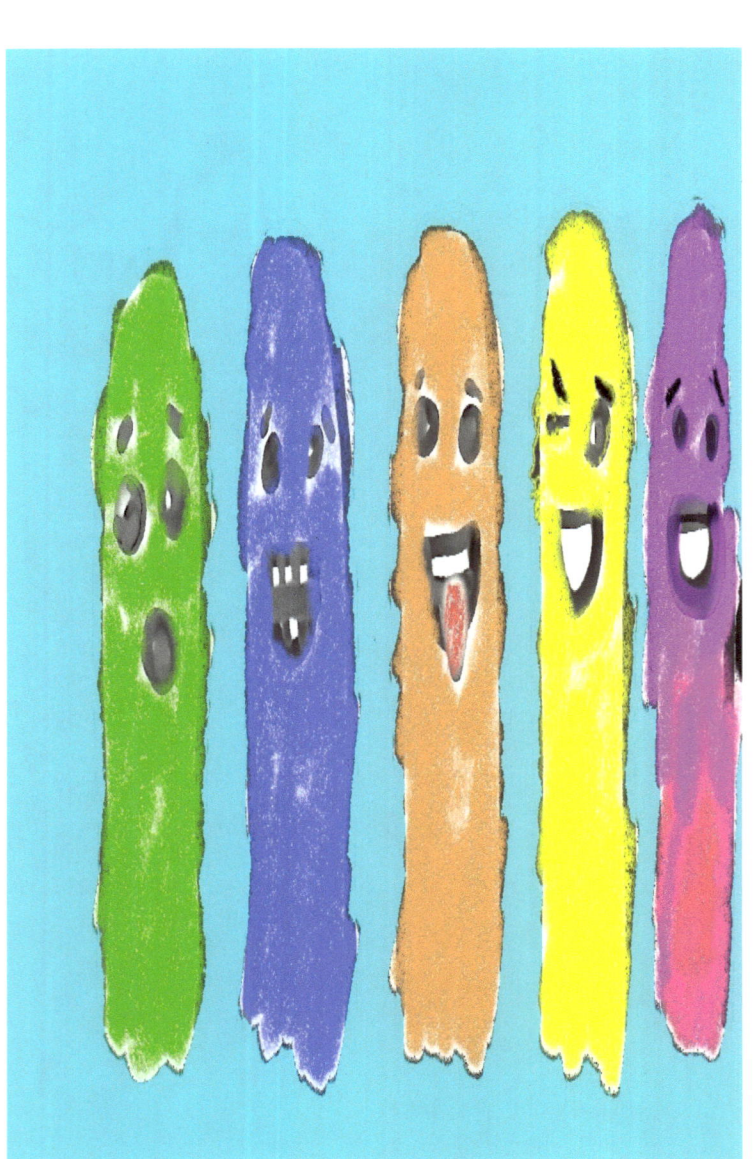

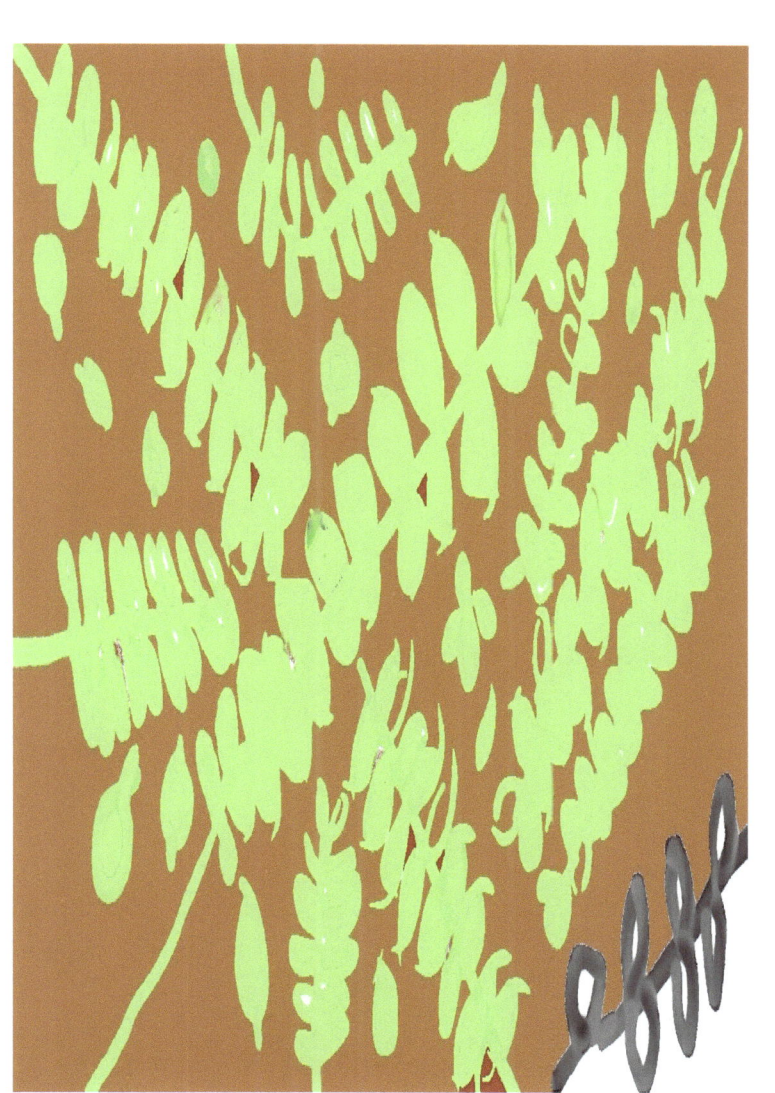

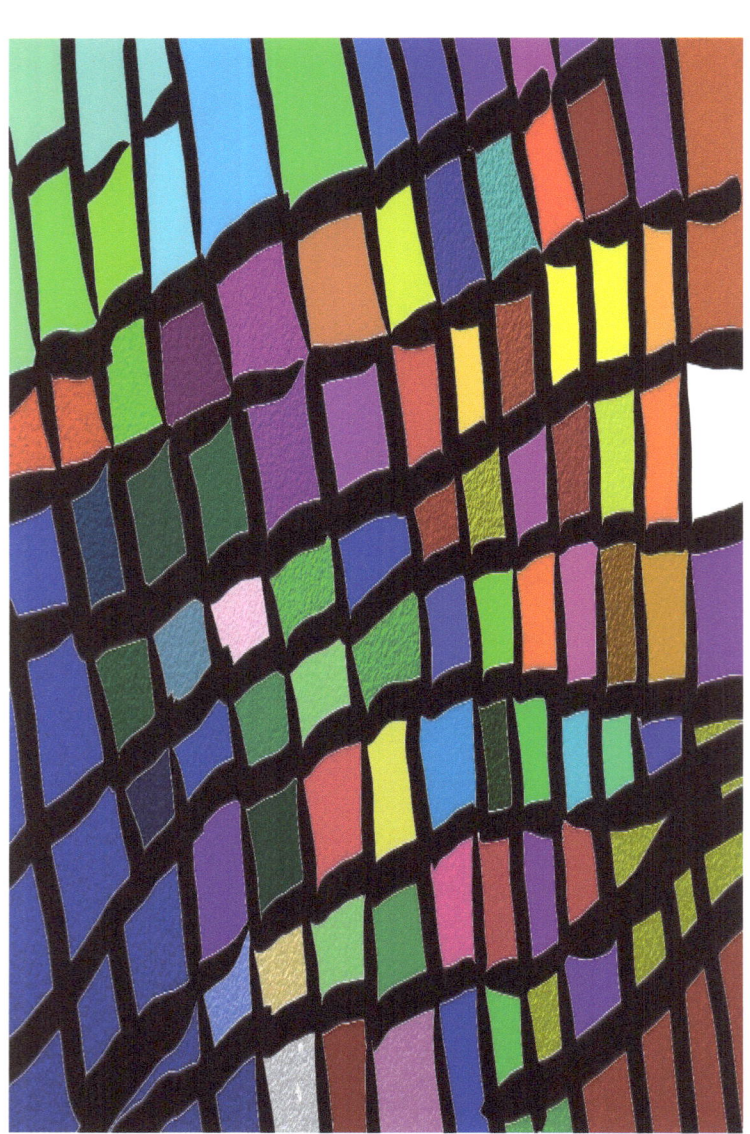

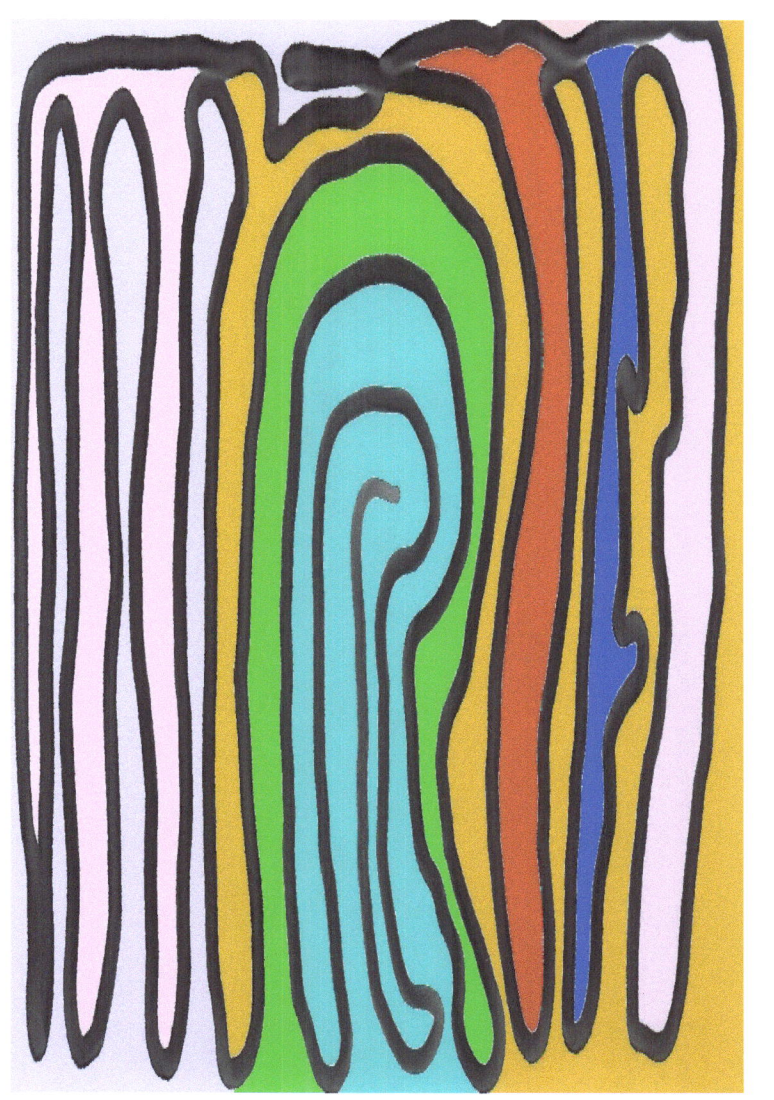

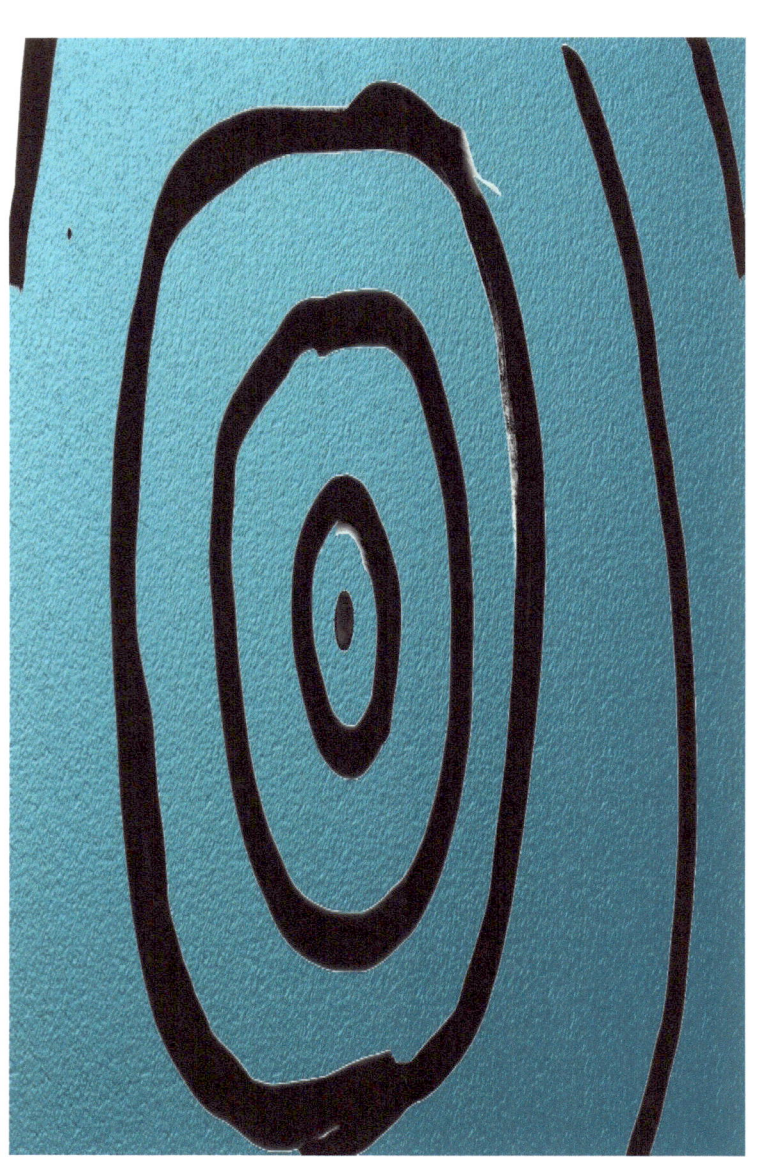

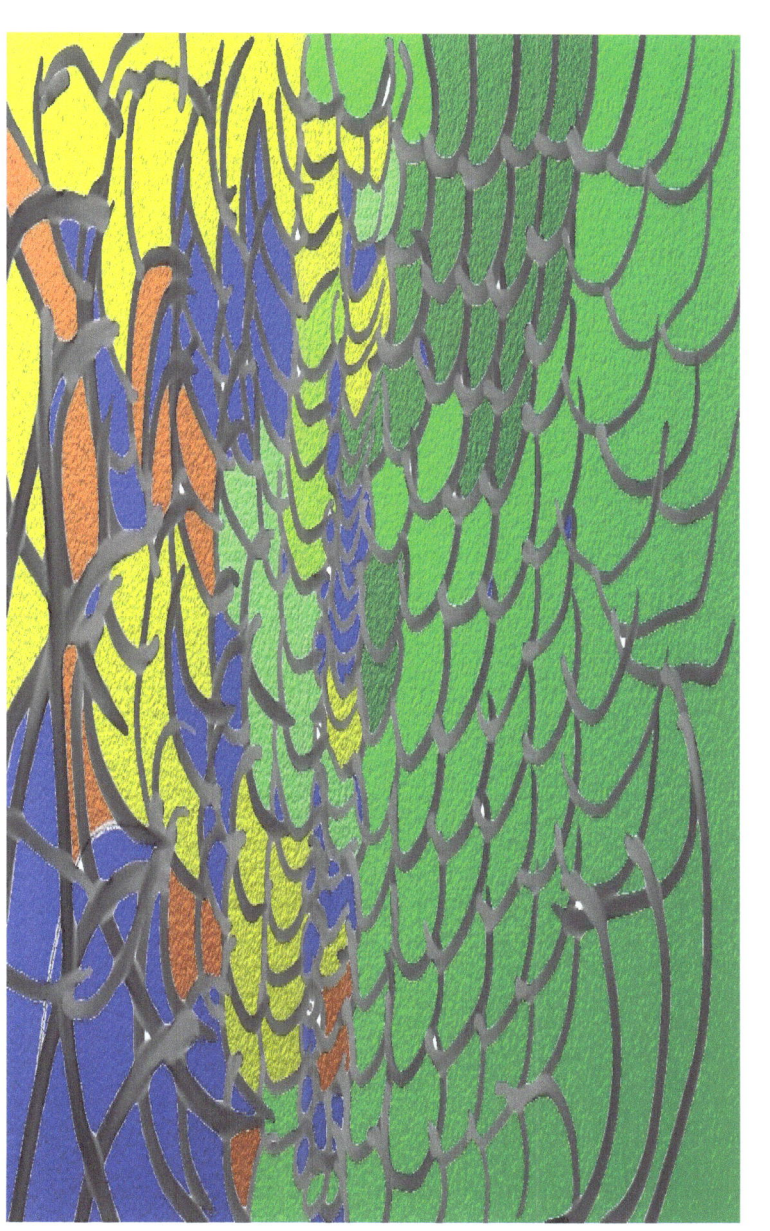

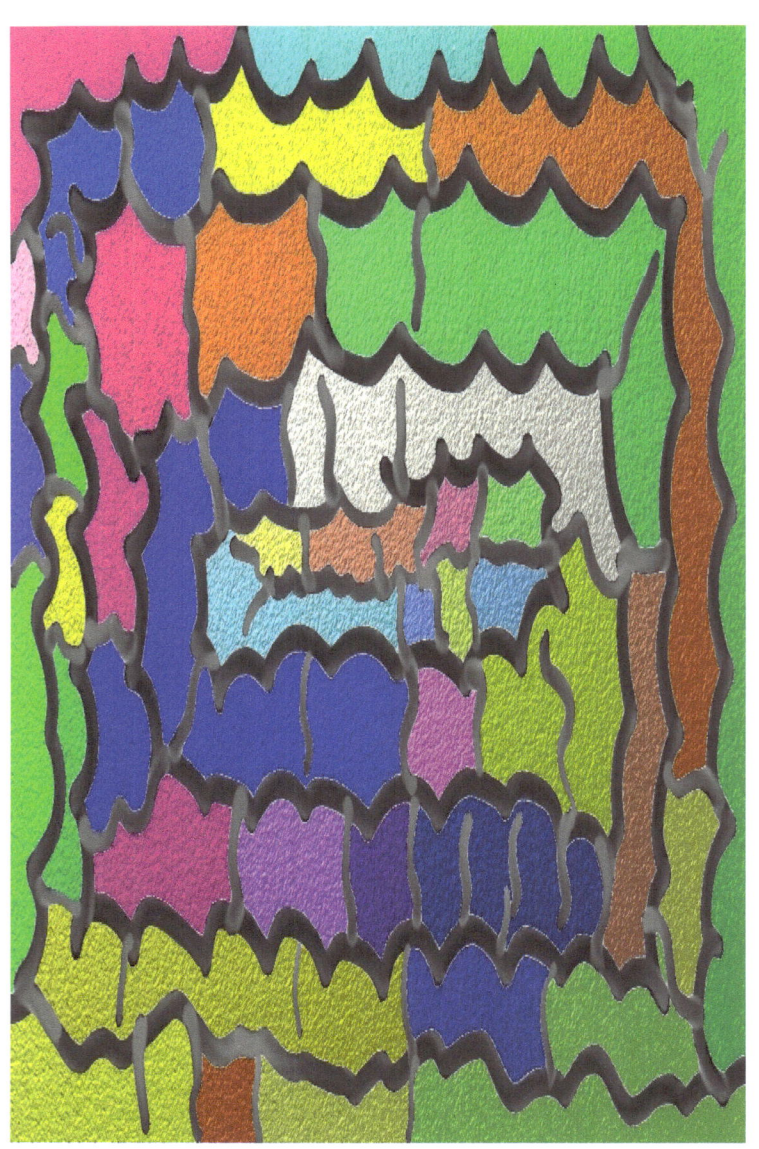

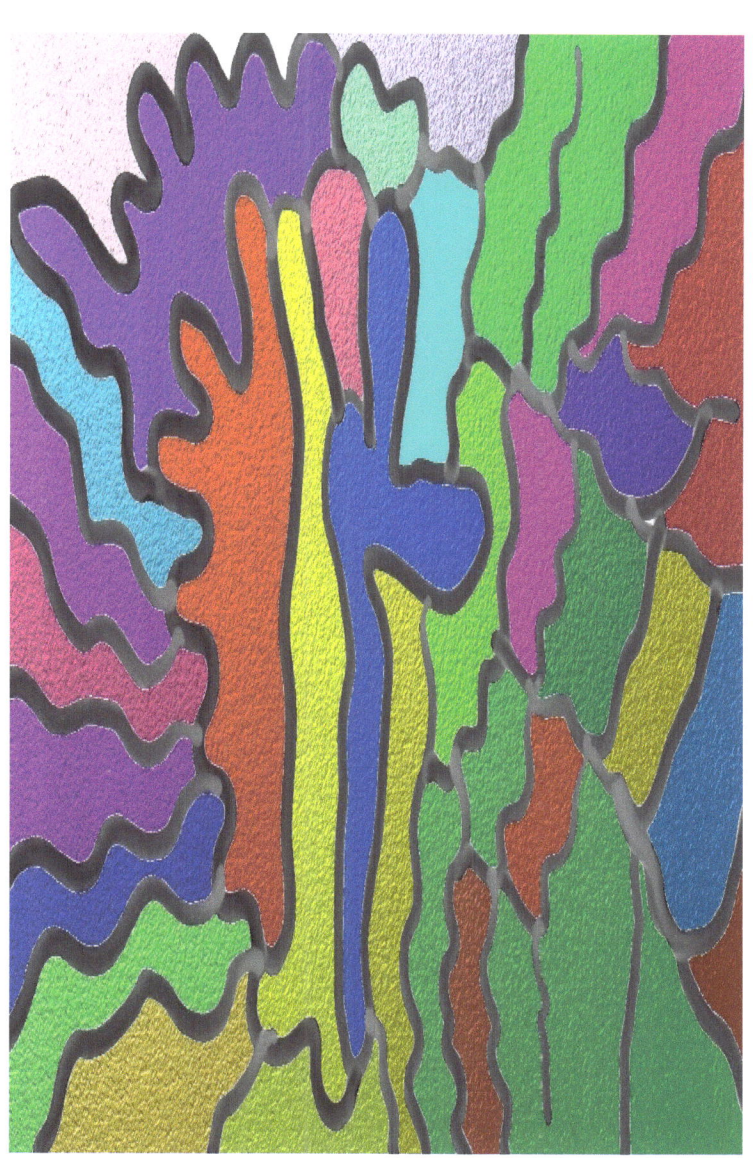

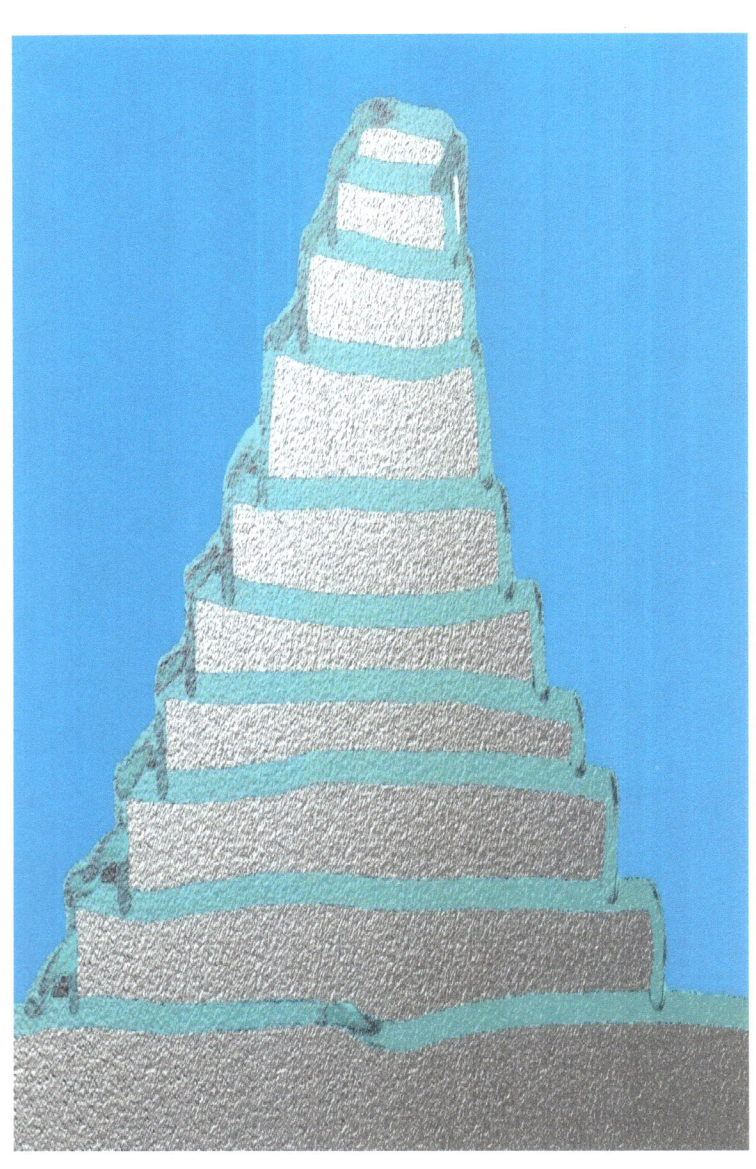

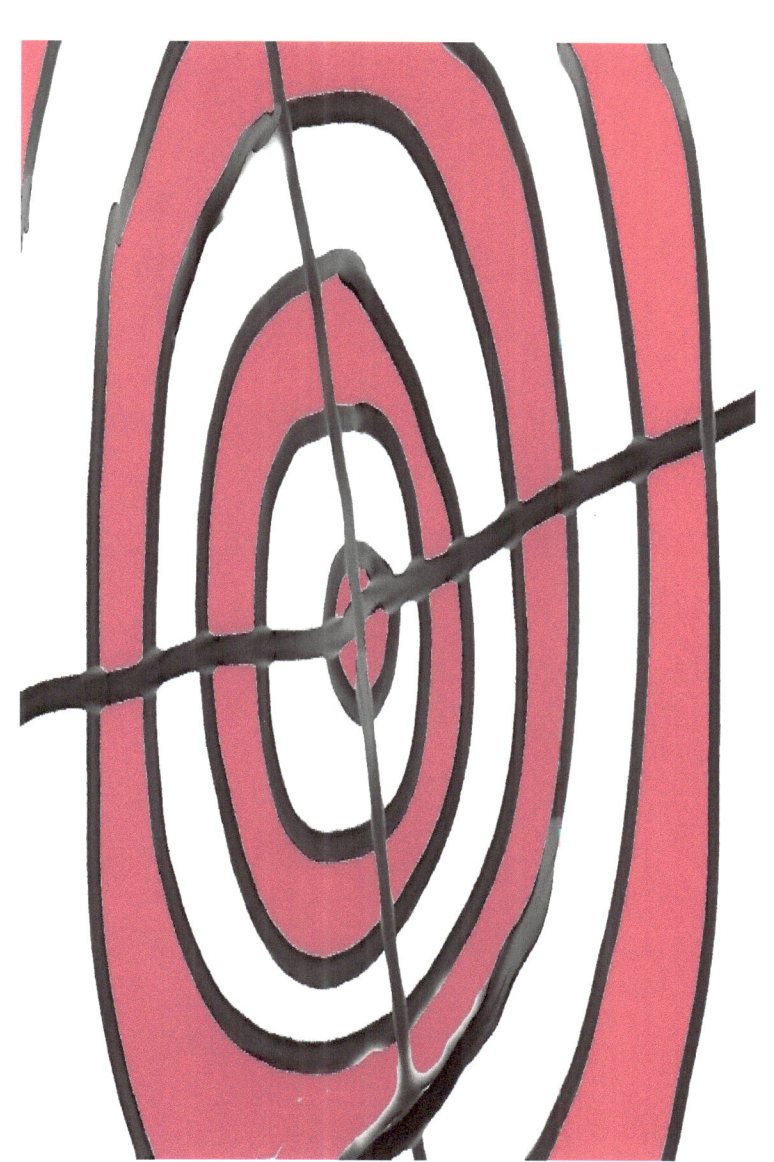

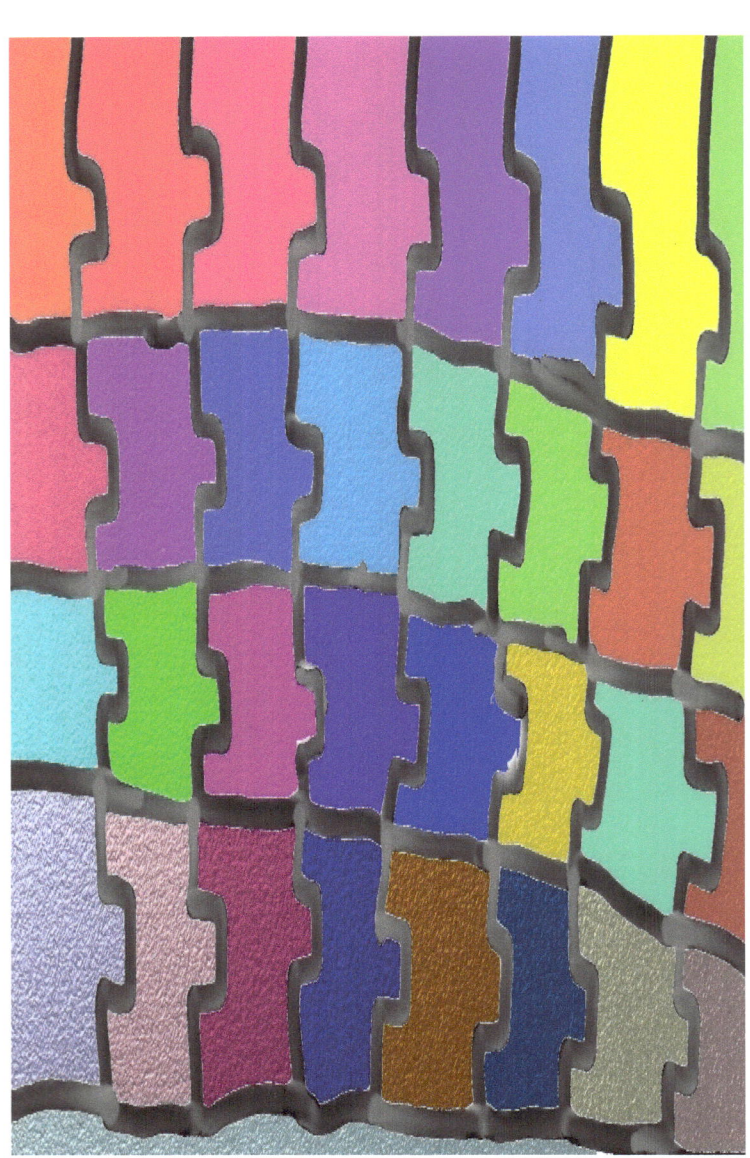

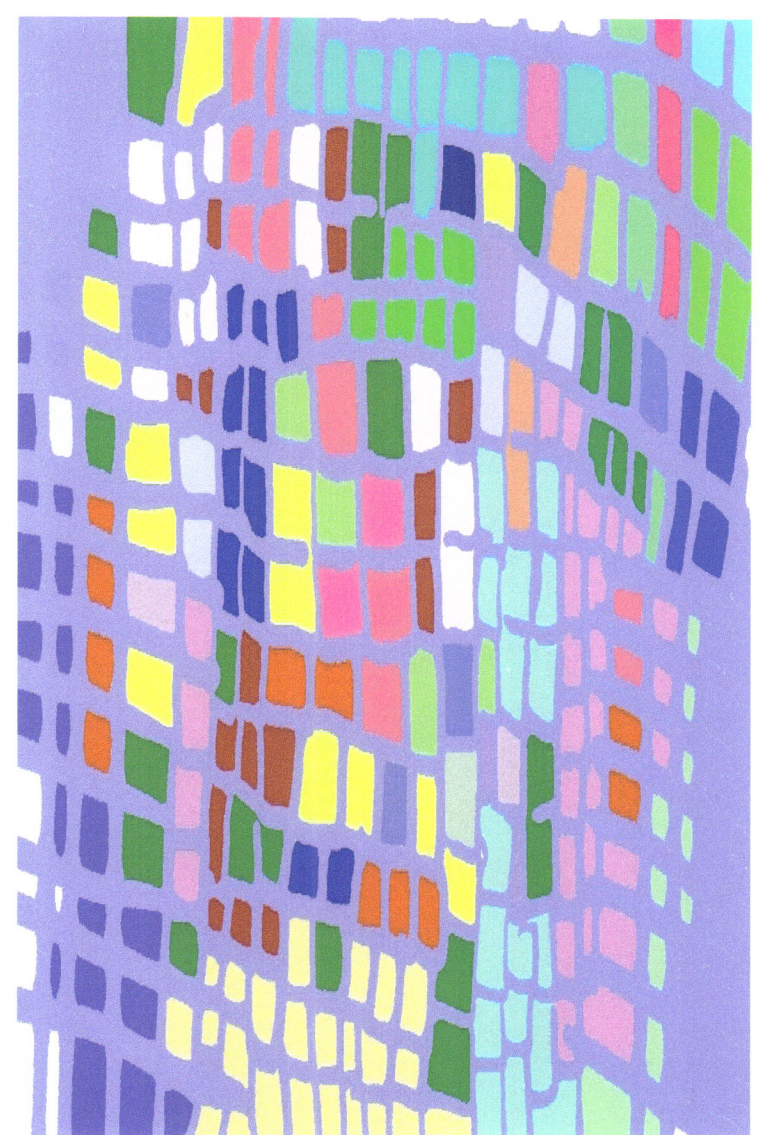

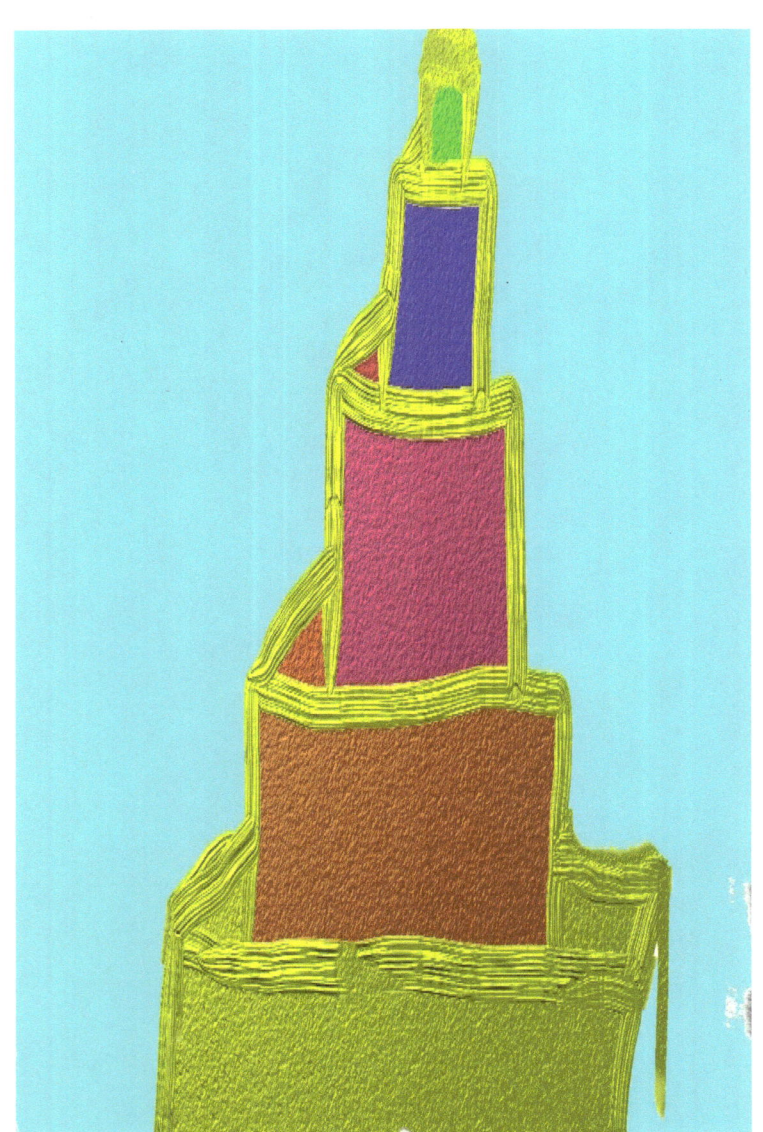

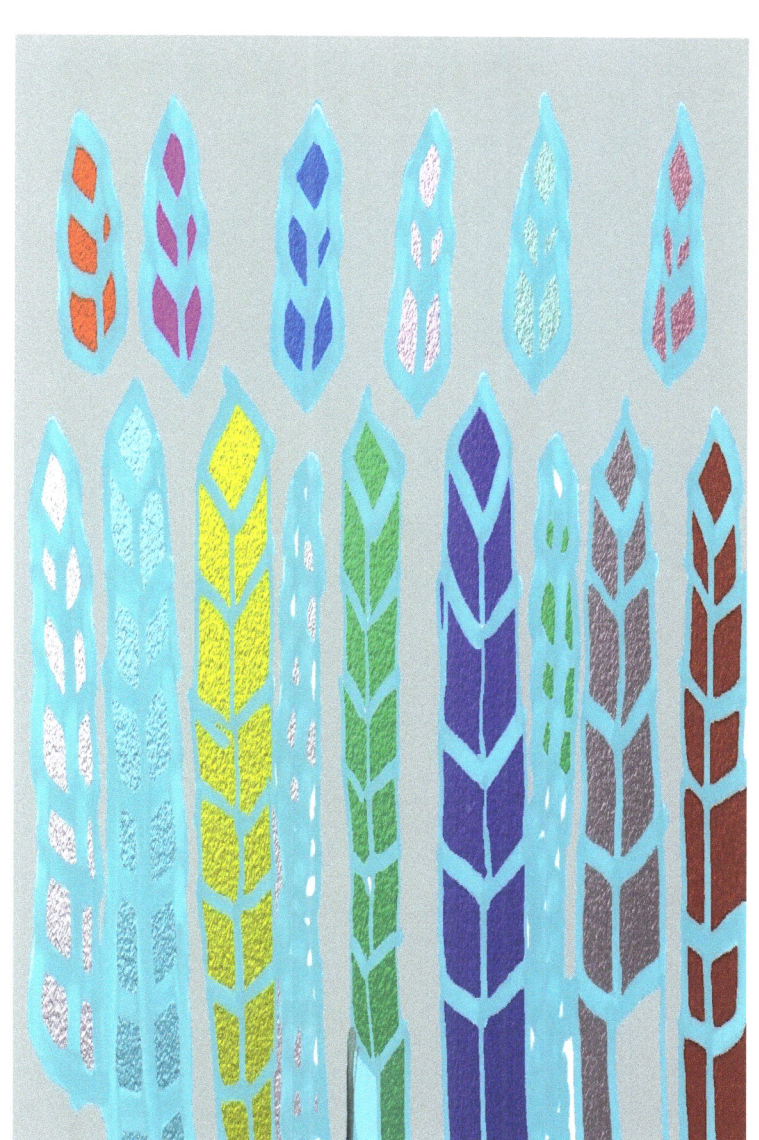

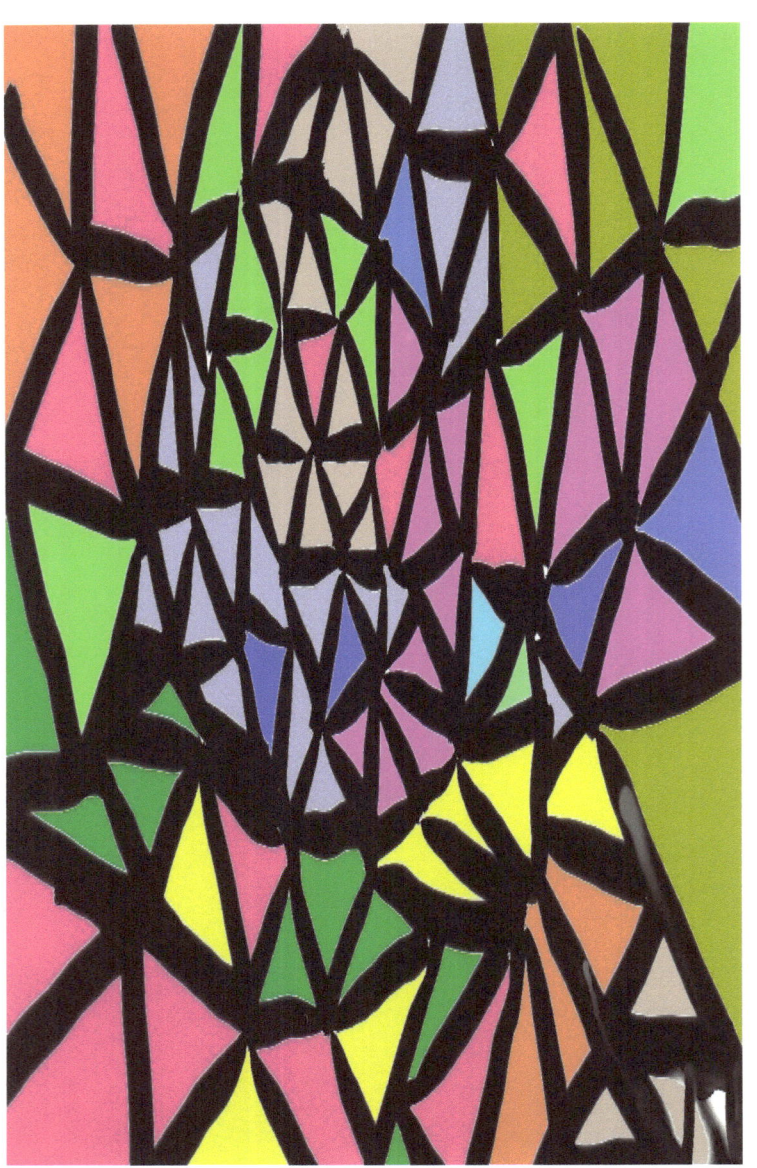

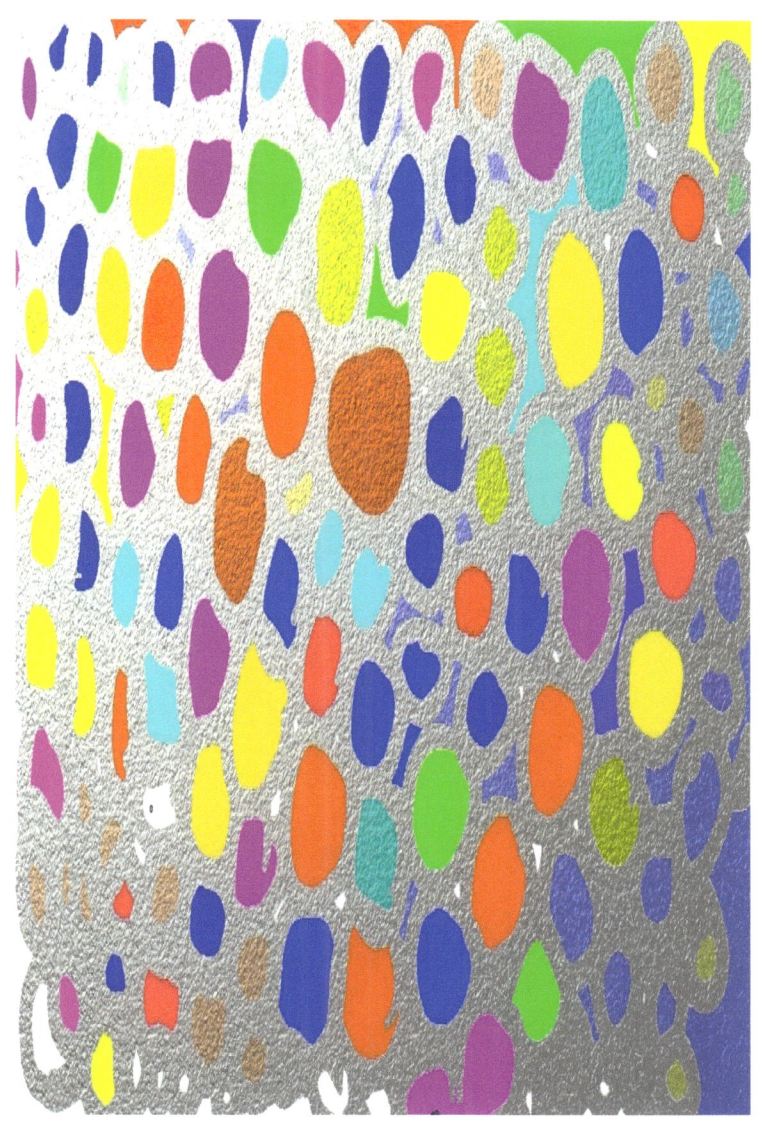

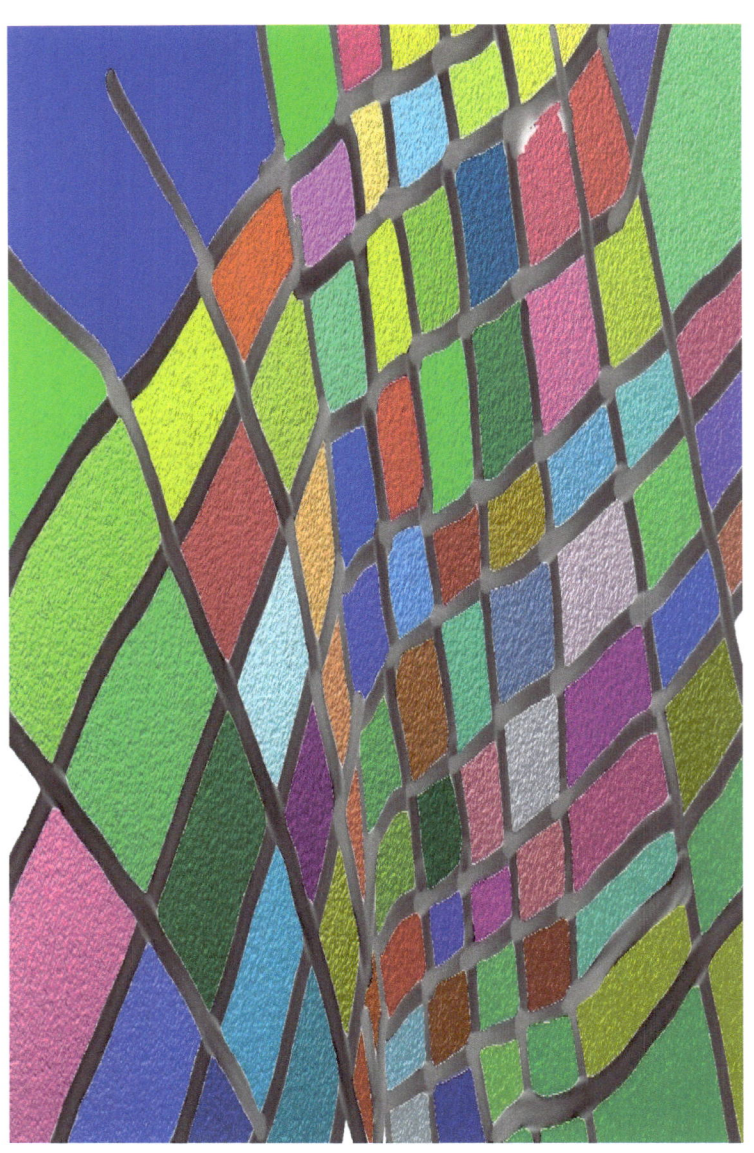

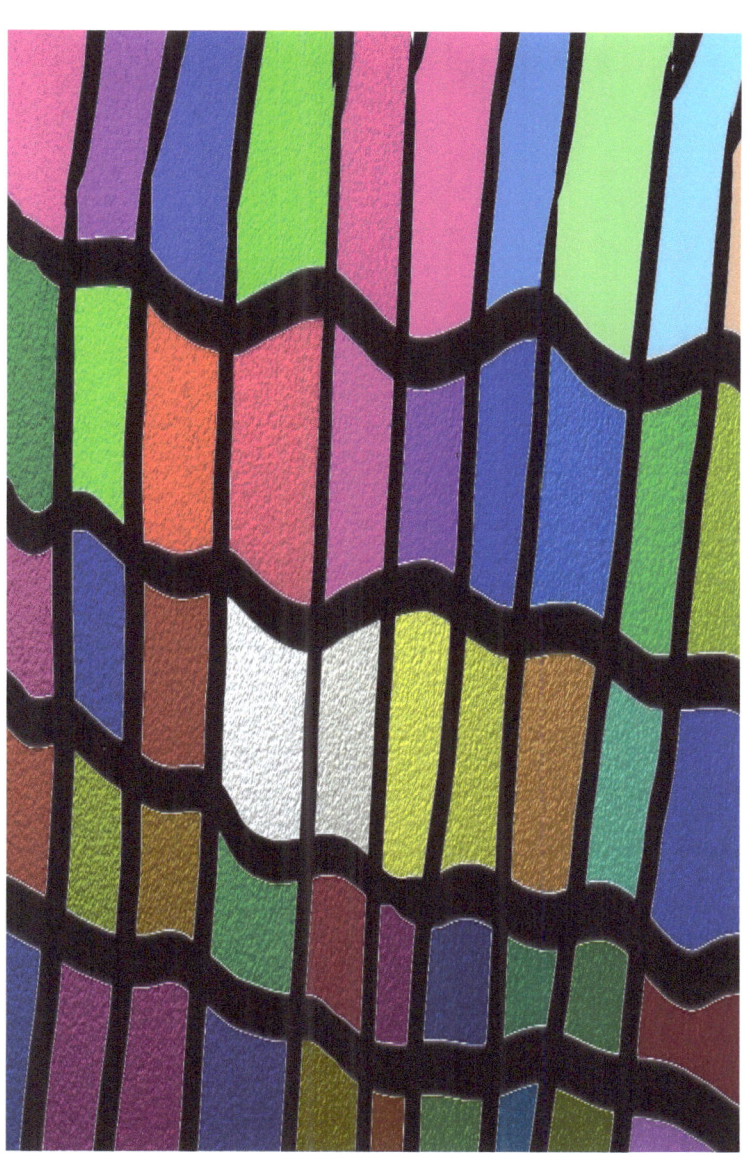

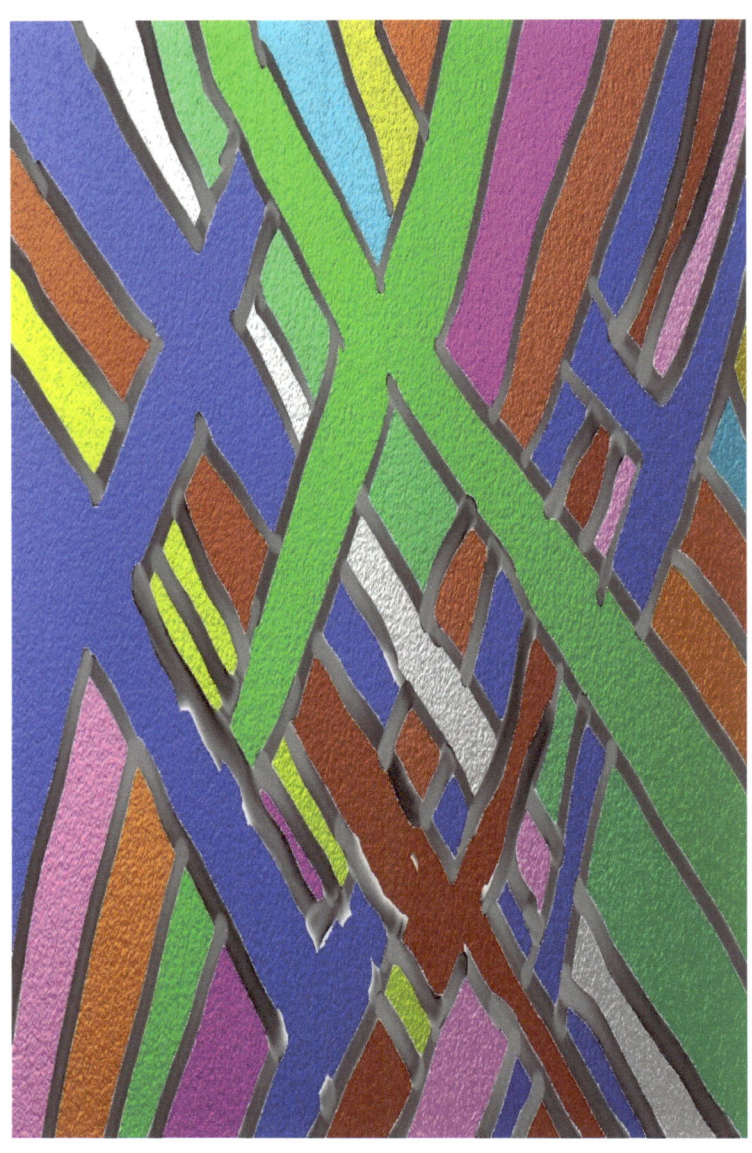

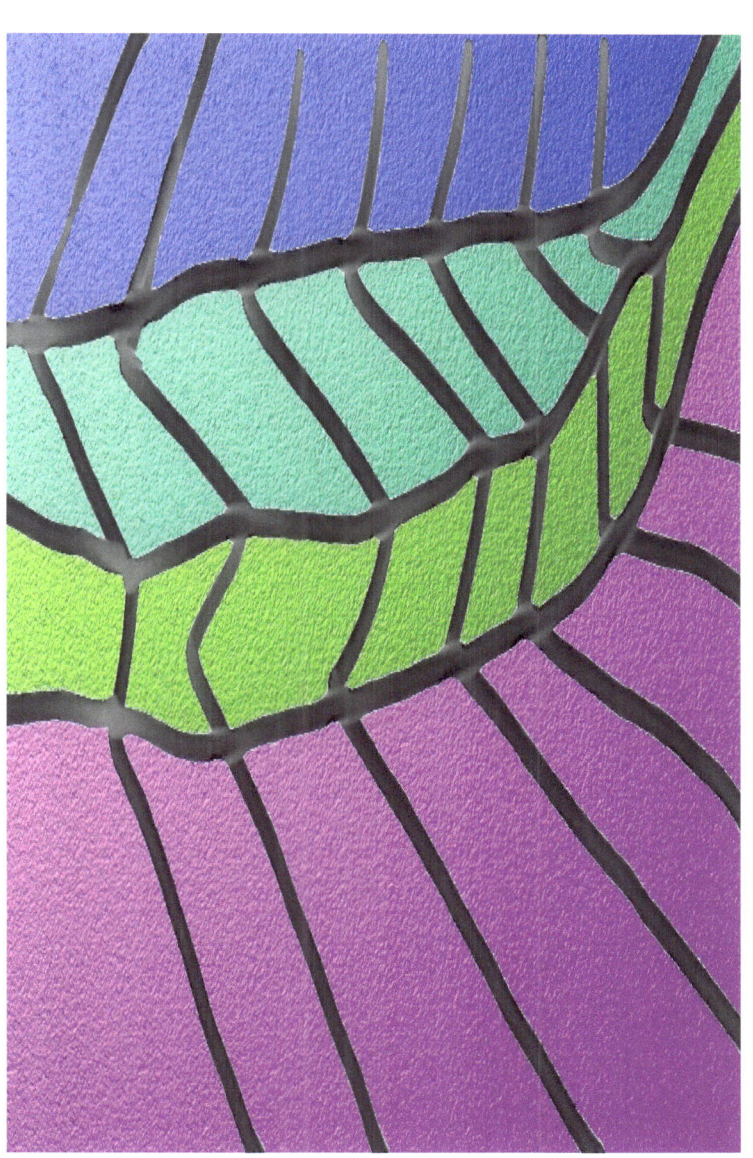

The End

www.ingramcontent.com/pod-product-compliance
Lightning Source LLC
Chambersburg PA
CBHW041213180526
45172CB00016B/240